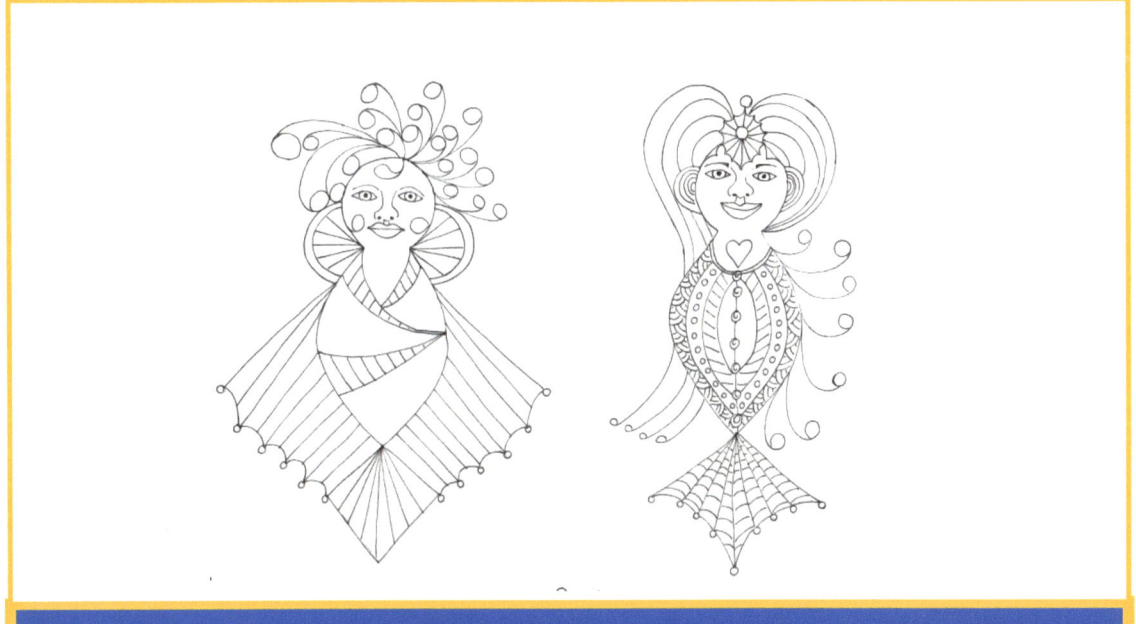

Spiritual Mermaids Colouring Book

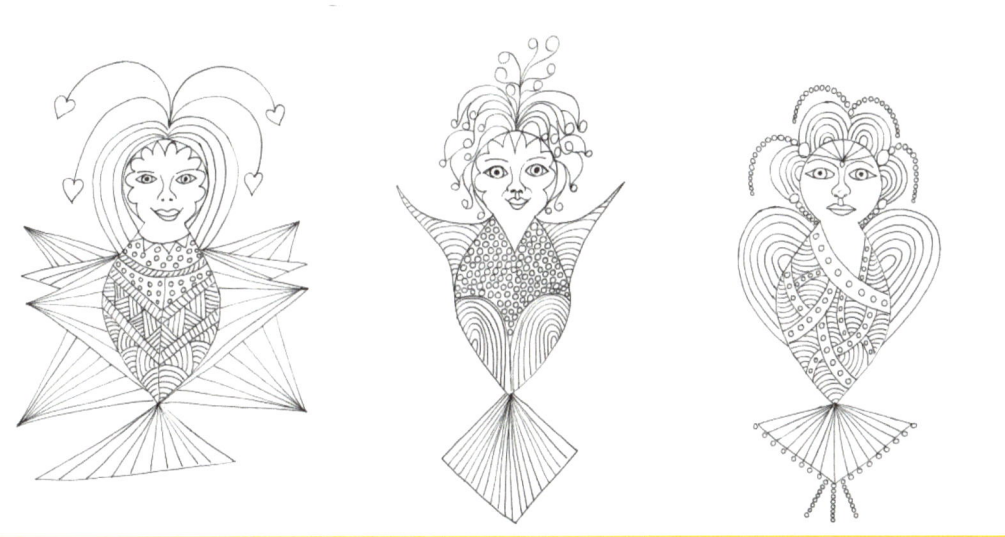

Copyright © 2019 by Alessandra Del Basso

**Published and distributed in Australia by: Inner Silence :
www.innersilence.com.au**

Design and artwork: Alessandra Del Basso

"Spiritual Mermaid Colouring Book" ® is copyright of Alessandra Del Basso

All rights reserved. No part of this book may be reproduced by any mechanical, photographic, or electronic process, or in the form of a photographic recording, nor may it be stored in a retrieval system, transmitted, or otherwise be copied for public or private use – other than for "fair use" as a brief quotation embodied in articles and reviews without prior written permission of the Artist Alessandra Del Basso. Any other use of any part in any form even and specifically derivative ART portion or whole portion can be produced without approved LICENSE of the Artist or any Licensing Agent involved in this project. Royalties apply to any product derived by use of the colouring pages [portion/whole/colouring page or derivative art]. Please ensure you have a licensed permission to act or use. The Artist maintains at all time copyright of the produce and royalty apply at any time for any event even if not specified here.

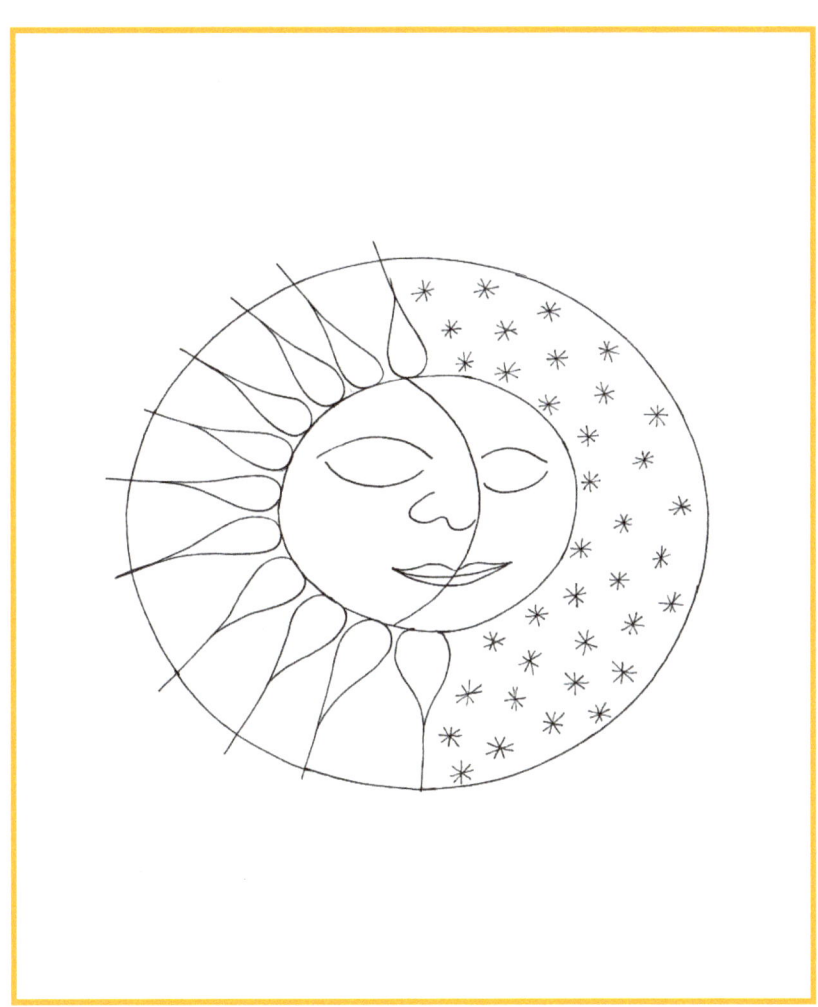

When there is no enemy within, the enemies outside cannot hurt you [African proverb]

This Colouring Book belongs to:

..

Introduction

This "Spiritual Mermaids Colouring Book" derives from my

own drawings and paintings used for the Journals

{see Amazon or innersilence7@gmail.com

to request a catalogue).

I hope you too will enjoy colouring in the pages and are

inspired to create your own.

Everything is possible "when you believe".

Luv and Light Alessandra

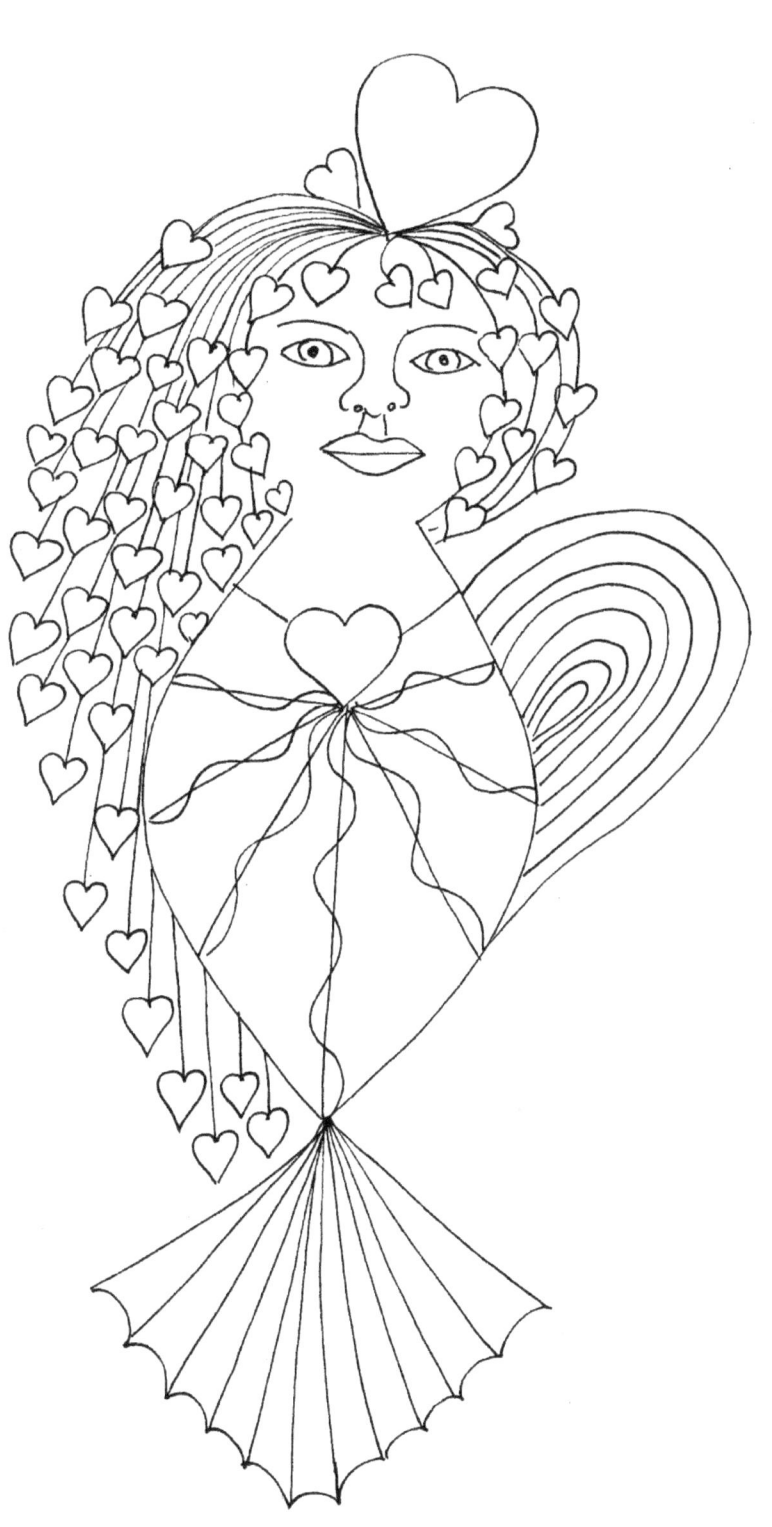

CREATE YOUR OWN

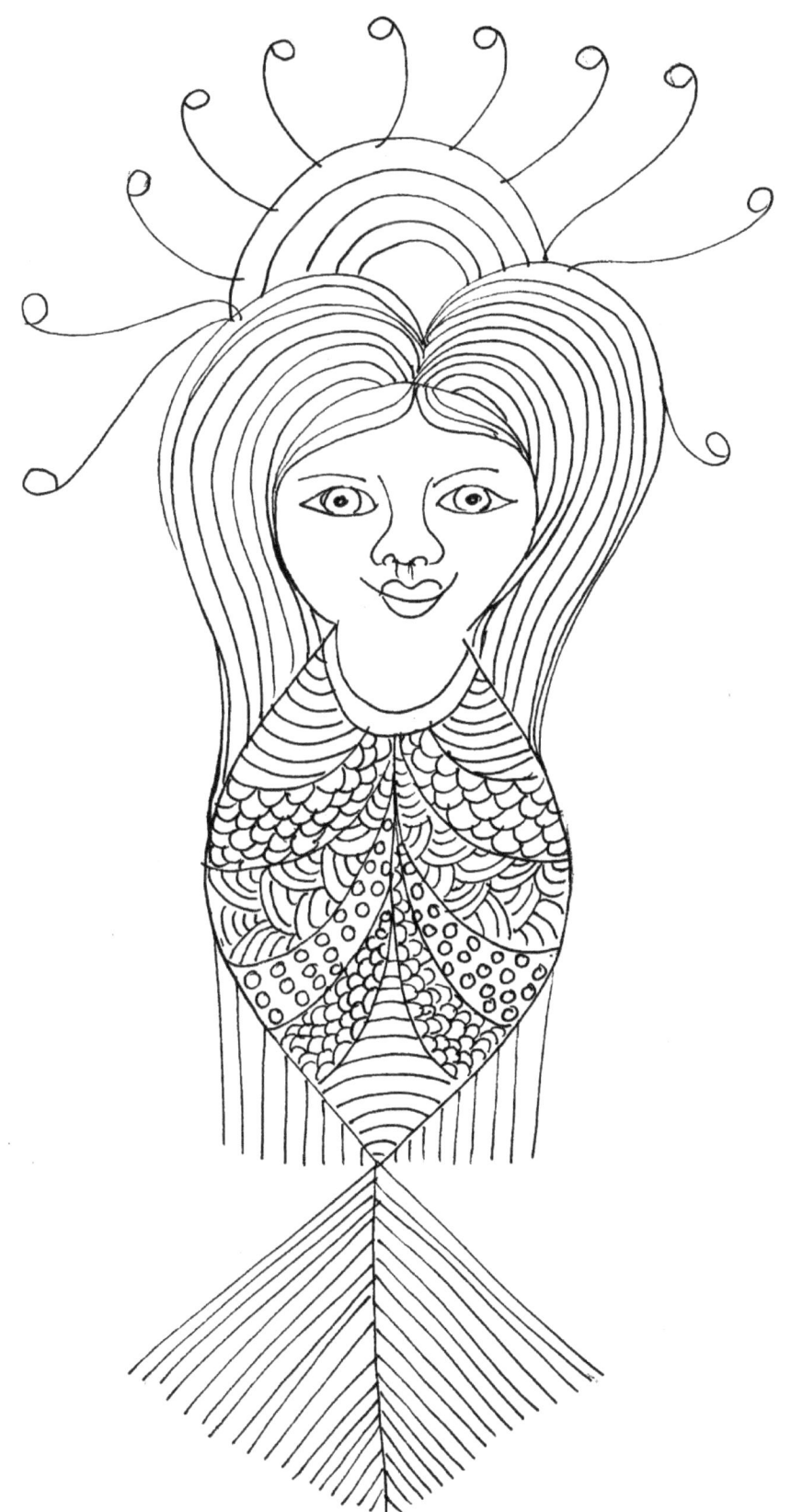

CREATE YOUR OWN

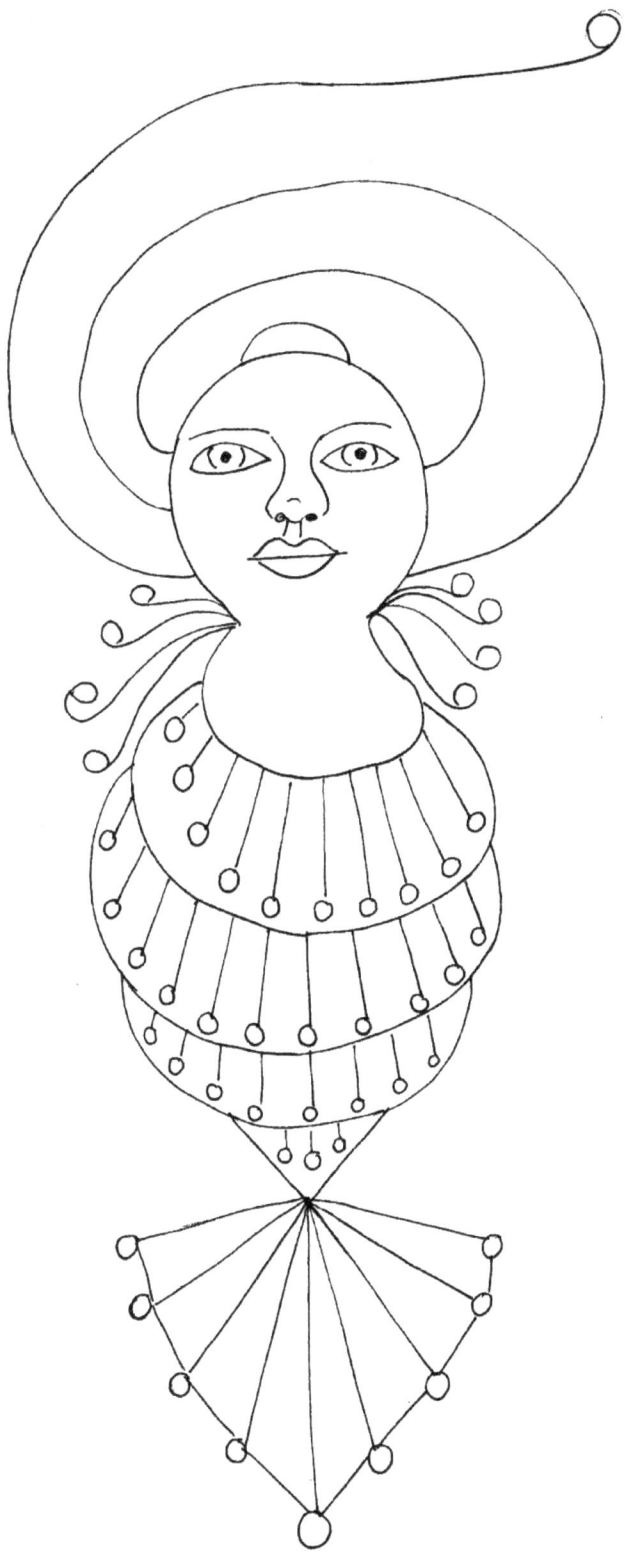

CREATE YOUR OWN

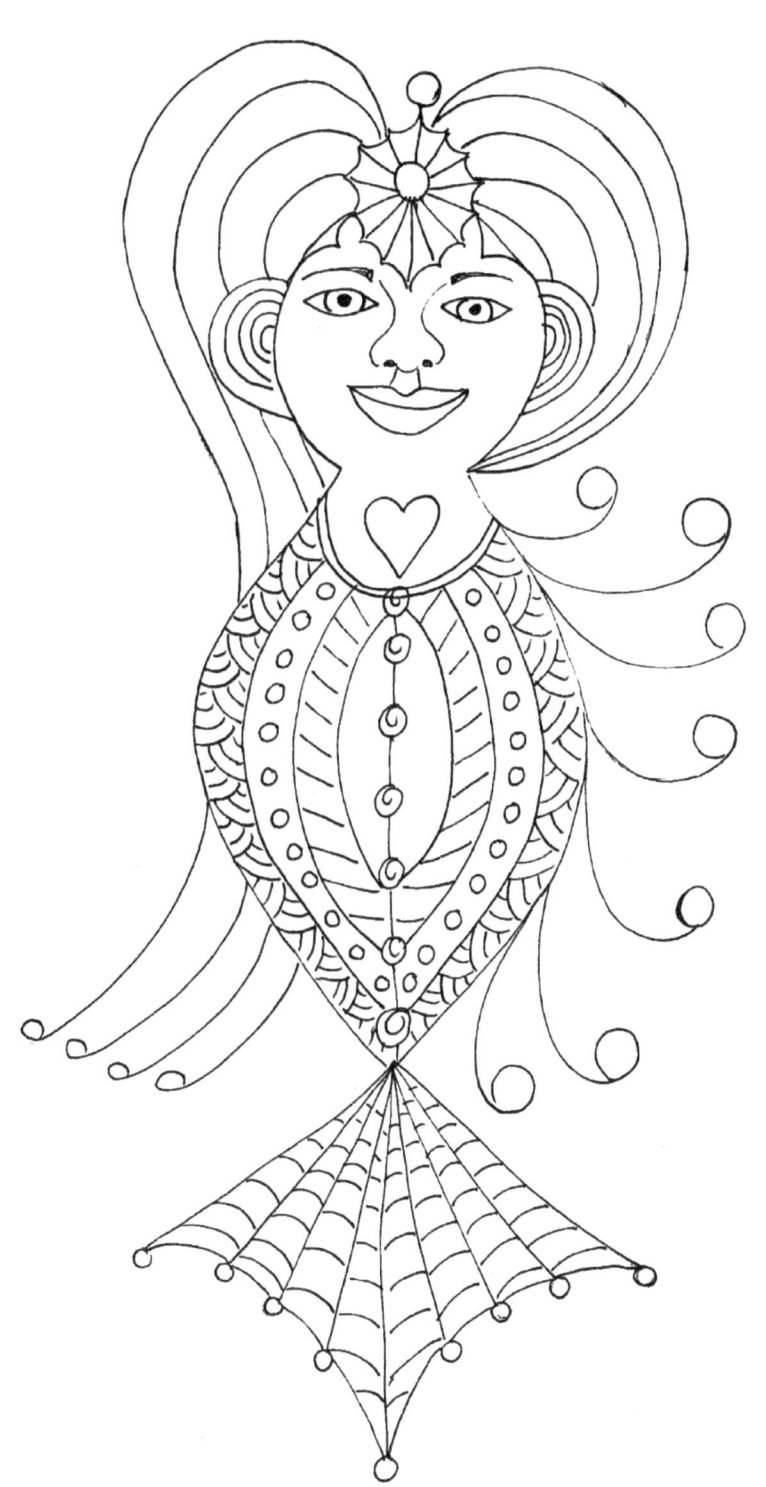

CREATE YOUR OWN

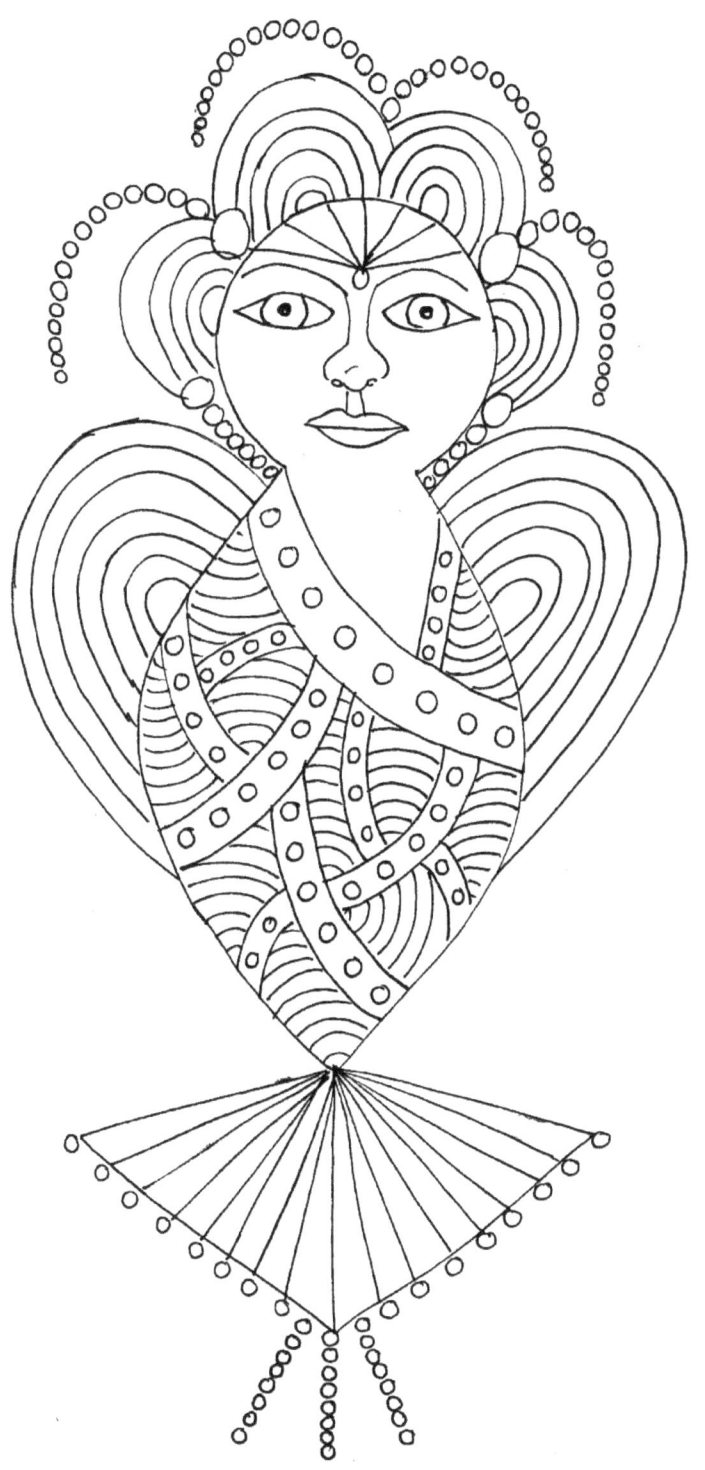

CREATE YOUR OWN

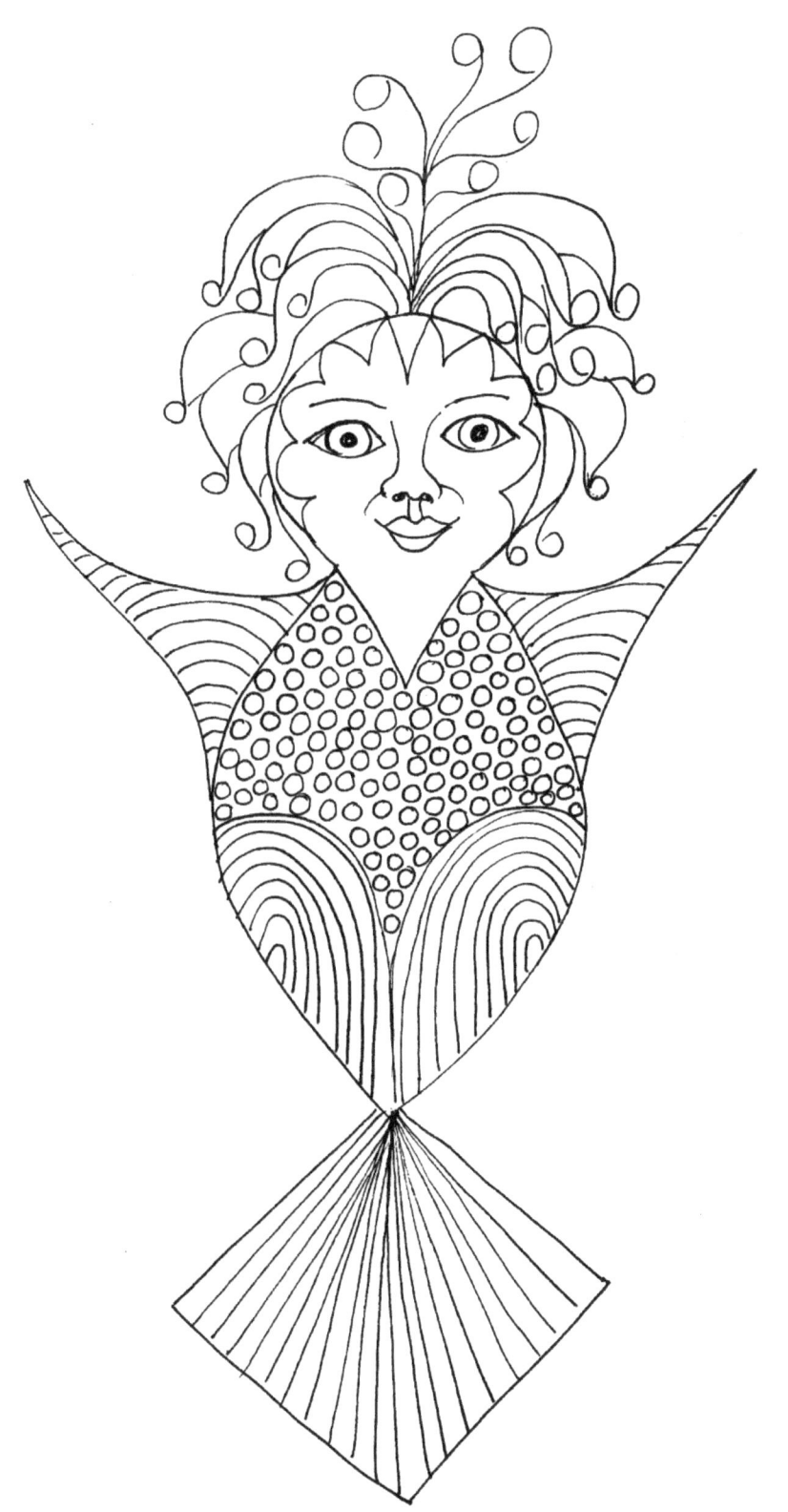

CREATE YOUR OWN

CREATE YOUR OWN

CREATE YOUR OWN

CREATE YOUR OWN

CREATE YOUR OWN

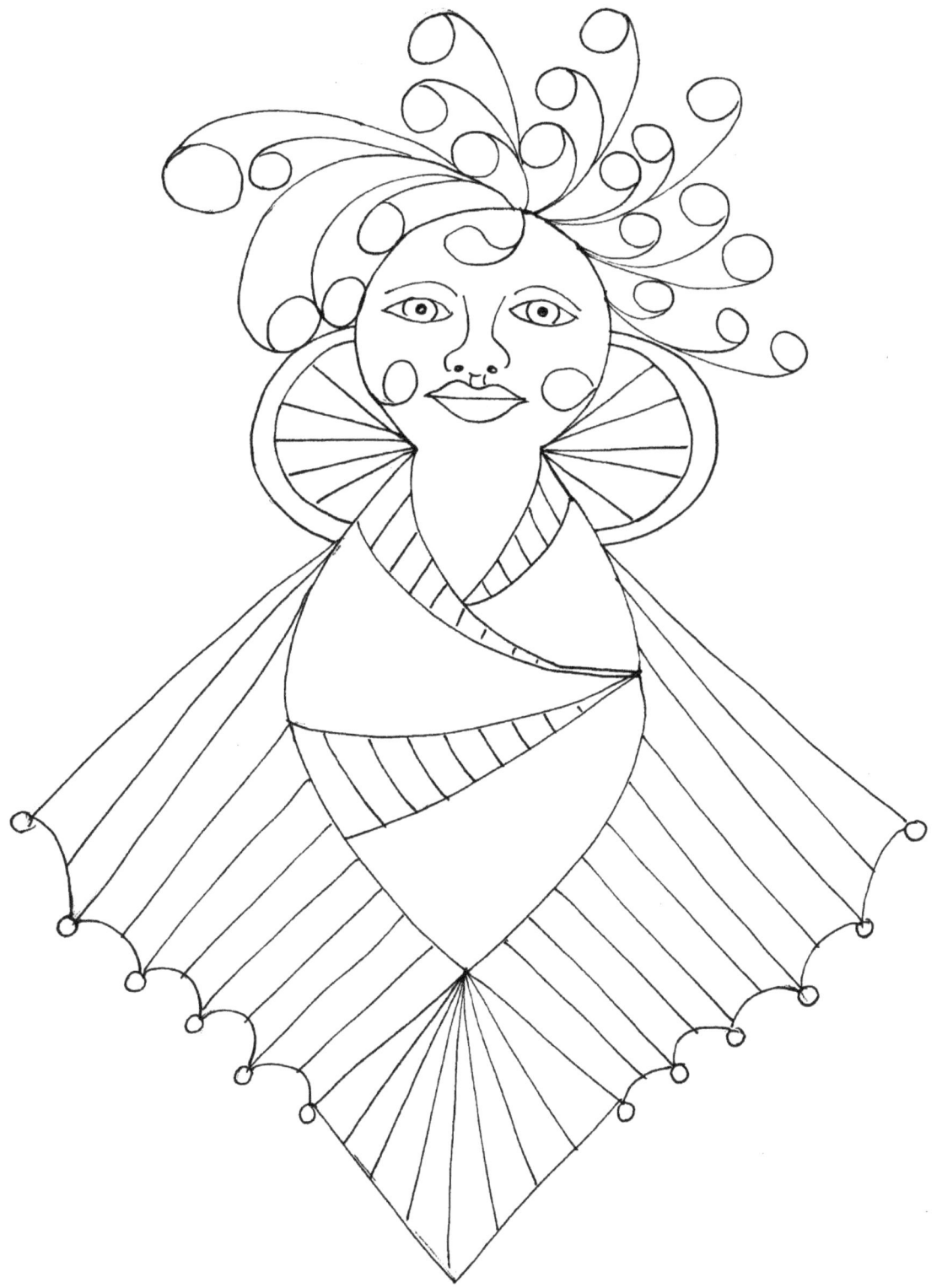

CREATE YOUR OWN

Journal about your experience:

Journal about your experience:

Journal about your experience:

Journal about your experience:

Journal about your experience:

About the Author and Spiritual Teacher: Alessandra Del Basso as all "Inner Wise Warriors"
has experienced a life of challenges and is aware of the many times she has fallen into the "Shadow" side.
This however brought her to start a search that would bring her to create "Rapport"
with her shadow sides and "SEE" the way to use this energy to fuel her journey rather than hinder it. As she drew this information out of the fabric of the Universal knowledge it also showed her the purpose of her life.

The Author's Life Purpose statement:

"I empower myself, so I can empower others and together we transform the Planet,

and we all prosper"

This "Spiritual Colouring Book reflects "passion" the author experiences along her path. It is the path of
light towards a more "creative" life and aims to invite you to see in your life the power of the
"Inner Creativity".
"Be the Creator of your life not the "slave" of your mind!!"

All rights reserved:

© of Alessandra Del Basso as the author & artist

www.ingramcontent.com/pod-product-compliance
Lightning Source LLC
Chambersburg PA
CBHW041301180526
45172CB00003B/917